Watch The Signs!
Watch The Signs!

Pub signs relating to science fiction, fantasy and horror

Dedications

To Gill, Dave, Todd and Sally, with who I have shared many afternoons and evenings inside the pubs, and all my friends from science fiction groups, conventions and gatherings everywhere.

Also Mary, Tim and John, who saved me from homelessness. Cheers one and all.

Watch The Signs!
Watch The Signs!

Pub signs relating to science fiction, fantasy and horror

Arthur Chappell

Shoreline *of* Infinity
Publications

ISBN 978-1-9993331-0-2

www.shorelineofinfinity.com

Publisher
Shoreline of Infinity Publications / The New Curiosity Shop
Edinburgh
Scotland
Typesetting and layout by The New Curiosity Shop

Cover artwork Mark Toner © 2019

Shoreline of Infinity Publications, The New Curiosity Shop and
Mark Toner are members of the Shoreline of Infinity Group.

030419

Contents

Introduction

1. Vulcan Arms

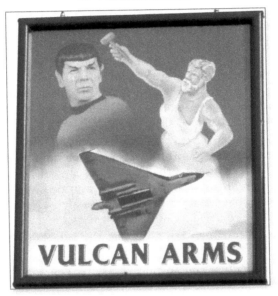

Vulcan Arms, Sizewell Gap Sizewell, Suffolk. IP16 4UD.
www.vulcanarms.freehostia.com
Image donated by The Inn Sign Society

If you think there are few if any pubs with a science fiction / fantasy / horror theme or connection, think again.

I'll start things rolling with this one as possibly the most obvious example, in that it neatly combines media SF, (Leonard Nimoy in his iconic role as half-Vulcan

and half human science officer Spock from classic Star Trek), the Roman god Vulcan drawing on fantasy, myth and legend, and a Vulcan Bomber reminding us of real science and technology.

There are quite a lot of pubs called The Vulcan, and the Pre-Christian deity gets depicted on many of them. As the god of volcanoes, metal-work, fire and blacksmiths, pubs linked to him by name were usually first located by industrial foundries, furnaces and anvils. Even when the industry had largely vanished, the pubs and name often survived and thrived. Vulcanized rubber manufacturing plants have also inspired pubs to adopt The Vulcan as their inn-names.

This is a recently commissioned pub sign which shows that even in the time of pub closures occurring at an alarming rate, new and highly inventive pub signs are still being created. The inclusion of Spock points optimistically toward the future.

Pub signs cover every theme under the Sun. In this book I also give general histories on signs and thematic talks. Just about any broad topic you can come up with has signs relating to it. In this short guide I'm going to show you just some of my favourite signs relating to fantasy, horror, science and science fiction.

The Vulcan Inn sign here won the Inn Sign Society award for the best pub sign of the year in 2011.

I'll introduce you to pub signs in general over the next few pages, then I'll tell you about how my own passion for pub signs developed before we really move into the weird, wonderful and unexpected.

Regrettably, the one thing I can't share with you on the pages to follow, is the ale itself.

The Origins and History of Pub Signs

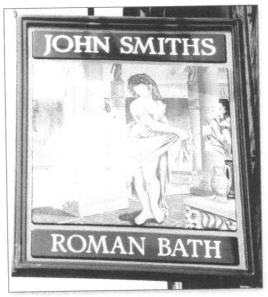

Roman Bath 9, St Sampson's Square York YO1 8RN.
Image donated by The Inn Sign Society

When the *Life Of Brian* movie listed the things the Romans did for us, ranging from the provision of everything from aqueducts to roads, the Monty Python team left out pub signs, which were almost certainly a Roman invention.

The Romans didn't invent beer, which has been with us from antiquity. There is a 3,200 year old carving from Cairo depicting the pouring of beer into stone bottles. The Romans preferred wine, but they were content to drink ale too, and wherever they went with their occupying forces in England, they marked out the

best houses offering alcohol by placing bushes in front of them and often rammed them into the thatching on property walls or rooftops. The sign of The Bush was not placed by every house offering beer and other hospitality. It was a mark of quality, and a recommendation that any chosen recipient property was a good, safe place to buy and consume ale. The Romans effectively introduced the first ever good beer guide. If you were given a Bush sign it was a powerful seal of approval from the occupying authorities.

Most beer was brewed for domestic consumption in the home, and most brewers were women until the Industrial Revolution. Making beer was seen as a routine domestic chore just as with baking bread, roasting a chicken and making cakes. Beer was a staple ingredient for the whole family as it was both tastier and safer to drink than water, because brewing involves boiling the water, hops, yeasts, etc. Water left untreated could give you typhoid, cholera and numerous other infections.

Some ale-wives (as they were called) inevitably brewed better beers than others, and started selling their surplus beers to the rest of the community and travellers, as well as the occupying Romans. The bigger a community got the more specialized the local trades and crafts became and it made good economic sense to have a few efficient ale-wives producing enough ale for the neighbourhood while other families performed other duties.

Bushes pressed into cottage thatch were still in use to represent ale selling houses until at least the early 17th century. Before then however, as Christianity took over the Roman Empire, there were massive movements of religious peoples around the country, church and cathedral builders, priests, nuns and monks, pilgrims, soldiers and the general faithful. The monks started providing accommodation inns (houses of hospitality) to temporarily house, feed and inebriate this traffic, which peaked in 1170 with the assassination of Archbishop Thomas Becket. His shrine at Canterbury sparked a

massive surge in the pilgrimage trail and promotion of sacred relics. Inns and tavern-houses were set up along the routes to cater for the pilgrims. These inns often later became the coach and horse stations for inter-town

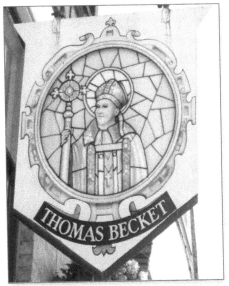

Thomas Becket 21 Best Lane Canterbury CT1 2JB
twitter.com/ThomasBecketPub

travel, and many inns had their own stabling yards attached.

Chaucer's *Canterbury Tales* starts at an inn, and other inns feature in many of the tales the pilgrims relate on their journey. Several of the tales carry fantasy elements too, Death personified, talking animals, ghosts, gods and demons abound.

The hospitality inn, a place you could stay residentially, helped attract tourism and trade to the towns, and the local population was catered for through taverns, where they could drink and eat but not stay for the night.

Already therefore, there were pubs associated with

religion, and with secular life. The movement of feudal knights added another element – the monarchical themed public houses were also on the rise with many pubs adding signs related to the heraldic shields of their favoured land owners, rulers and employers.

The Canterbury Tales
12 The Friars Canterbury CT1 2AS
www.facebook.com/thecanterburytalespub/
Image donated by The Inn Sign Society

There were problems with pubs though. A 'pint' in one pub could be a different measure than a 'pint' in another, similarly with wine measurements. Worse, some publicans were watering down the sold beers and wines. A call for set standard beer measures was incorporated into the Magna Carta in 1215.

King Richard II went further in 1393 and issued a decree that all pubs in the land must be licensed, and failure to serve quality ale in the correct measures meant a loss of license, which was to be displayed in the form of an inn-sign. If your inn sign was removed by

Magna Carta – 1 Exchequer Gate Lincoln LN2 1PZ
www.facebook.com/magnacartalincoln/
Image donated by The Inn Sign Society

the authorities or you didn't display one, you were soon out of business. The first true pub signs were not just an advert for a pub, but a way of showing the premises was licensed, much like a car has to display its tax-disc today to show the driver has paid all due annual road tax.

Ale conners roamed the land testing the quality of ales. They didn't drink the beer – they sat in it. Beer gets sticky, so if a beer was right to taste it would stick the back of the conner's breeches to a wooden bench – too watered and he wouldn't struggle to get up off the bench and the publican would possibly lose his sign and license. Ale conners sound comical to us now, but they were feared and often despised authority figures who could destroy a publican's livelihood overnight.

Early fixed pub signs were called ale stake or gallows signs, and they were usually presented on a long pole that was set horizontally from out of the walls of the pub, reaching out over the roads to catch people's attention.

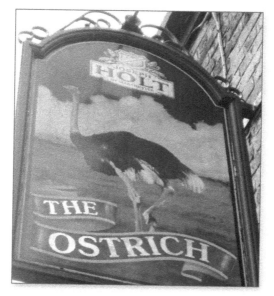

The Ostrich – 163 Bury Old Road Prestwich Manchester
M25 1JF
www.facebook.com/HoltsOstrich/

The ale stake was growing unpopular by the early 18th century, especially after one in London's Fleet Street brought down a supporting wall and killed four passers-by in 1718. That was when the four by three oil painted on tin design mounted on swinging brackets design became more popular, a close fore-runner to the main framed fixed bracket signs we see on Britain's public houses today.

Most signs were exclusively pictographic at first as most people couldn't read lettering and the images were usually tied to pub names. With six pubs in one town sharing the same name, all trying to honour the same monarch, earl or local hero, the signs could often be similar enough to cause confusion. Artists therefore started diversifying more. Also, after Henry VIII started the Protestant Reformation, signs became increasingly more secular and less religious or political. It was safer to avoid controversy.

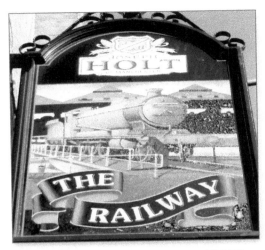

The Railway – 82 Dean Lane Manchester M40 3AE
www.facebook.com/RailwayNewtonHeath/

The scope for pub sign artists expanded enormously. Instead of depicting the whole of (for example) Sir Edward Coke's heraldic shield insignia, an artist would notice that he had ostrich feathers in his plumes, and then just paint an Ostrich, as with this sign in Prestwich, Manchester. Ostrich is also a distortion of hospice which associates with the aforementioned monastery run guest houses on the pilgrim trails (Hospice meaning place of hospitality rather than small hospital).

Pub sign designs were therefore already diversifying when Manchester's great Cottonopolis hold on the Industrial Revolution sparked the rise of the working classes, represented through canal navigation pubs, Railway Hotels, Miner's Arms, Butcher's Arms, Bricklayer's Arms, etc.

The Napoleonic, Crimean, Boer and later World Wars our heroes fought and died in led to pub signs that are as much a memorial to the fallen as the great stone monuments at which we lay our poppy wreaths.

Every sign in our fair land tells a story, each sign has its own aesthetic and cultural value – a pub sign

The Frigate (1943 HMS Headingham Castle) Thatch Leach
Lane Whitefield Manchester M45 6FW
www.facebook.com/JH.Frigate/

in its frame turns the pub and the street into an art gallery. You can look at an image hanging from a pub sign just as you can assess the merits and beauty of any portrait in the Tate or Turner galleries. You don't even have to go inside the pubs or touch alcohol to appreciate inn signs.

The following book addresses the signage that relates to and draws direct inspiration from books, film and TV shows in the horror, science fiction and fantasy genres.

I'll now briefly explain how I came to be drawn to this unusual hobby.

My Personal Interest in Pub Signs

While I can remember reading science fiction since before puberty, and took my first beer at about the age of twelve (c.1974) my pub sign obsession only began in October 2009.

It was the year my stepfather died, after which my mum kindly gave me his digital cameras. I decided to use them to take photos relating to my writings which happened to include a poem with a quite direct reference to a real local pub sign in Moston, North Manchester.

This is the poem that started it all, though the poem was penned two decades earlier.

BEN BRIERLEY (1825-1896).
When I wrote my first dialect poem
The critics said 'take more spelling lessons;
We think you've got dyslexia.' Back home
I cried all night, and searched for the reasons
Behind Brierley's success. Manchester's
Famous 'dyslexic' poet, with an inn
Named after him, which sells beer to punters
Who know little of their poet's rhymin'.
From his pub-sign, Ben's pen swings in the wind,
As he dreams up one last verse; but there's
No more dr(ink) for him I am determined
That one drunkard will think of him, so here's
To you Ben. Di'lect's lost on me, but cheers.

I was in no particular hurry to re-visit the Ben Brierley pub which I knew I was bound to pass on my travels sooner or later anyway, so I was saddened when I finally got there to find it closed down and its sign removed. I'd missed my chance by about three days. I quickly noticed that two other pubs in the same area had vanished as well.

Almost on a reflex I snapped off a shot of the very next pub sign I came to The Piccadilly in Manchester city centre. I looked closely both at the image on the camera and the sign itself and a lightbulb exploded in my head telling me that I now had a new highly addictive pastime. Within hours I had a score more of Manchester city centre's signs under my wing. Now I have thousands of pub sign photos in my personal collection, plus images kindly shared with me by friends.

The Piccadilly sign captures the three age of tram travel in the city, so even from the first image I captured there is a sense of time-travel. The pub has since changed hands, name and sign, (becoming The Piccadilly Tavern) so this sign no longer exists.

I was collecting for several months before I looked online to see if others collected pub sign photos. I discovered a small friendly well-run organization of like-minded fans. The Inn Sign Society has just around 300 members but I am glad that I am one. This publication is very much my own independent work however, and should not be seen as reflecting views necessarily shared by other member of the ISS.

Exhausting the easily reachable signs of Manchester I started taking train and coach trips further afield, and when visiting other towns or cities I invariably try to make time to capture at least some of their pub signs on camera too. My current home in Preston has given me a whole new area to explore with my camera too, in Central Lancashire.

My study of pub histories and my photo-collection itself now allows me to visit towns to give illustrated

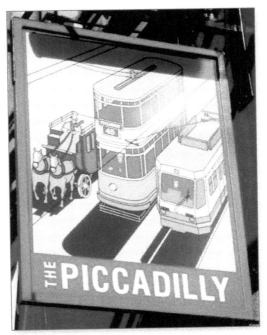

Now called The Piccadilly Tavern – 71-75 Piccadilly
Manchester M1 2BS

talks on signs close to the community being addressed
and my talk to the attendees of the 2017 Innominate
Eastercon science fiction convention then led to this
book. I hope you gain as much from reading it as I gained
from writing it. I also hope that in visiting or passing
pubs on your own travels and adventures, you take a
moment or two to look up and appreciate their signs.

Watch The Signs!

Points to Keep in Mind

Pub signs are rarely as old as the pubs themselves. Most signs are painted with oil on tin, so after about 20-30 years the weather can ruin them. Some signs may be reproduced with the same design while many pubs and their breweries commission artists[1] to come up with fresh images. Even if the pub dates from the 14th century, its sign almost certainly does not.

There is no correlation whatsoever between a pub sign and what the pub is like on the inside. The greatest pub sign you ever saw might still adorn a lousy pub, selling flat beer, while some great pubs have no inn signs at all. This often highly subjective study is therefore not a good pub guide or a good beer guide. I personally prefer drinking in pubs that serve real ales but whether a pub serves keg only or cask as well is totally irrelevant to my pub sign collection quest.

The rate of UK pub closures is frightening, so some pubs described here may well regrettably vanish before you get to read this book.

While facts are as accurate as I can make them, opinions expressed are very much my own personal views. I welcome reactions, corrections, and suggestions for follow up studies and revision for future edition of this publication too.

Some friends assume my hobby indicates a truly impossible degree of alcohol consumption on my part. I like beer but I have not been in every pub for which I have a sign-photo. On some walks I capture dozens of

[1] Most sign creators work anonymously, though a few can be identified. The most famous artist to work on pub signs (mostly in London) was William Hogarth (1697-1764).

signs. On one visit to London I took 137 pub sign photos in a single day. I had beer in just three of those bars.

Pub sign wording is likely to offend strict grammarians. Sign-writers dislike adding too many words to their pretty pictures so the definitive article (The) and apostrophes (') are often disregarded.

Deciding on whether a sign is good or not takes in many factors:

1. Does the sign look neat and clean or show signs of weathering and grime?

2. Is the sign unobstructed by hanging flower baskets, lighting, flags, or Satellite dishes?

3. Does the sign offer an interesting if not unique interpretation of the pub name, especially if there are other pubs of the same name?

4. Does the sign reflect the history and culture of its location?

5. Are there unusual details and talking points?

6. Does the image create any controversy?

7. Is the sign any different on the other side from which you first approach it?

8. Does the sign have a purely aesthetic value? If it was a commercially available painting or poster, would you be willing to buy it and display it yourself?

9. How well is the sign framed or set flush to the wall of the pub (or set apart from it on a stand or gallows pole)?

10. Do you consider the 'newer' sign an improvement, or in some way worse than any previous signs used to promote the same pub?

Fantasy Fiction Signs
– Beast Fables.

Fantasy fiction gets way more portrayal on pub boards than science fiction, and most towns and cities will have signs relating to beast fables and anthropomorphic animals.

Let's start with this one:

10. The Old Fox And Hounds

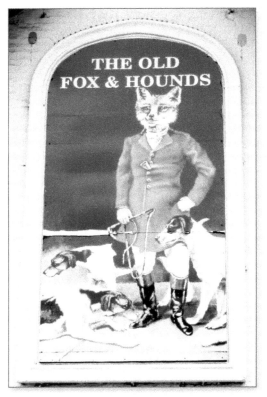

1 London Road Croydon CR0 2RE
www.facebook.com/The-Old-Fox-and-
Hounds-134211586634131/
Image donated by The Inn Sign Society

The Fox isn't being hunted here, but leading the hunt, controlling the hounds that would normally be chasing him. Maybe he is a giant hunting small humans. Could this be a *Planet Of The Apes* spin-off, Planet Of The Foxes?

Hunting pubs are extremely common; The Fox, Fox And Hounds, Hare And Hounds, Dog And Partridge or Dog And Pheasant pubs are legion. At one time the signs

would have shown more realistic images of the hunt, but with growing opposition to blood sports the animals have been made more friendly, or cartoon like or as in this case, given human characteristics.

Of course fantasy writers have humanized animals for a long time; clothing them, giving them religions and philosophies. If the Old Fox here was on the cover of a novel by William Horwood (aka, *Duncton Wood*), or a movie poster for a Pixar movie we wouldn't be remotely surprised.

11. The Waltzing Weasel

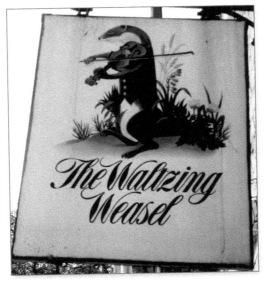

The Waltzing Weasel
8 New Mills Road Birch Vale High Peak SK22 1BT

Here is another variation on the theme of an animal using human cunning and clothes; the Weasel seen here is leading the dance with his fiddle playing.

Weasels actually do dance, (but without violins). it's an erratic eccentric way of leaping about that draws small curious critters closer to try to make sense of

what the weasel is doing, and when one gets too close, the weasel pounces out from the dance at lightning speed without warning and catches its lunch.

It is no accident that Kenneth Graham made the weasels the main villains in *The Wind In The Willows.*

12. Fox & Grapes

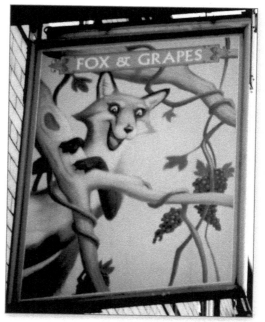

Fox & Grapes
Ribbleton Lane Preston PR1 5LE

Quite a few pubs are named after this Aesop beast fable. The grape has obvious associations with wine and again there is a strong connection with the hunt. In the fable the fox tries to get to the grapes but eventually gives up dismissing them as sour, leaving us with the expression 'sour grapes'.

Aesop's Fables are among the earliest examples of

fantasy flash fiction.

In this beautifully painted sign the fox is clearly successfully getting to the grapes, even though in reality foxes prefer chickens to fruit.

13. Tan Hill Inn
(AKA The Wolf And Whistle)

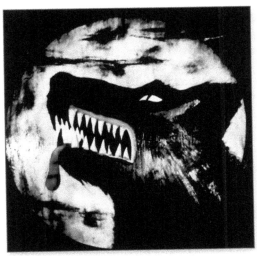

Tan Hill Inn (AKA The Wolf And Whistle Yorkshire Dales National Park, Long Causeway, Richmond DL11 6ED www.tanhillinn.com

This was a challenge to pin down – although the sign for The Wolf and Whistle was known to me, finding the pub was surprisingly difficult. That is because this made-up sign is actually inside a real pub with a different name, The Tan Hill Inn.

This sign behaves rather like a werewolf in its human guise hiding its dark secret away from those who might cause it problems.

The full moon suggests werewolf as opposed to wolf, and it is a pretty fierce looking creature. The whistle

is more intriguing as we can't see it, though the wolf might hear it, possibly as a posse of hunters with silver bullets try to trap it and kill it. Someone seeing it blows the whistle to draw in the other hunters. The wolf howls in distress, maddened by the noise and possibly to warn other members of the pack of approaching danger.

The pub (the highest above sea-level in England) also has pentagrams and other occult memorabilia on display.

The sign and its related trappings were actually created for a Vodafone ad made for TV that spoofed the pub scenes from the movie, *An American Werewolf In London*. The fake sign and arcane paraphernalia was left at the real pub after filming was completed on location there. The ad was one of a series starring Kyle MacLachlan, who starred in David Lynch's *Dune* movie and *Twin Peaks* TV series (and its movie prequel) and other genre works.

14. The Drunken Duck

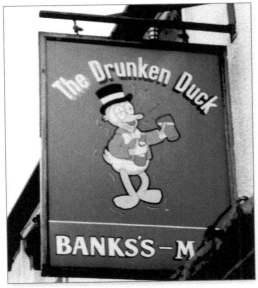

The Drunken Duck
55 High St, Walsall WS9 9LR

To round off the opening fantasy sub-section, I could easily go on with pub sign depictions of eagles (a few of who do appear later in different contexts), falcons, owls, bears, bees, dog, cats, rabbits, hares, lions, deer, horses and more besides.

To do so would lead to me single handedly wiping out a rain-forest for even a short print run, as virtually any of these critters turns up in one fantasy or many. Bambi (deer), the Lion (King), Owls (Harry Potter's Hedwig), while Rudyard Kipling's Jungle book offers an entire menagerie. I'll settle for a bleary-eyed duck in a posh hat and a blue blazer. He has a bottle and a full glass in his hands, suggesting that he has rather too much of a taste for alcohol. He has forgotten who and what he really is. Perhaps that is the danger of anthropomorphism. The animals take on human failings as much as they absorb our noble qualities.

Watch The Signs!

Judaeo-Christian Mythology

15. The Angel

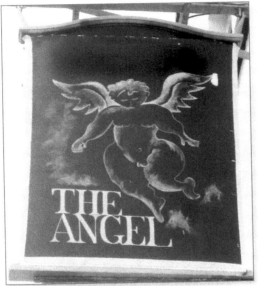

6 Angel Street., Manchester, M4 4BR
www.facebook.com/AngelPubMCR/ and
twitter.com/TheAngelPub

As stated earlier, many early inns served the pilgrimage trails, and were run by monks, enabling guests to receive accommodation, food and drink, including wine, ale and mead. Many pubs therefore took on religious names, and signs depicting religious imagery including fabulous scientifically questionable beings like angels.

This angel takes on quite a dark dangerous looking

mood; there is no Christmas cheer or promise here. She looks ready to do some serious smiting.

This pub is situated on the corner of a once notorious North Manchester (Collyhurst) slum district known as Angel Meadow, described in all its squalor even in the works of Friedrich Engels. No wonder the angel looks angry.

The image has since been replaced by a reproduction of a less menacing looking angel from Michelangelo's Sistine Chapel.

Angels appear in much fantasy work by C S Lewis, Philip Pullman and Neil Gaiman among others.

16. The Devil's Stone Inn

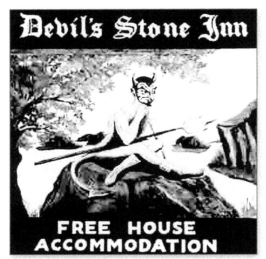

Shebbear, Beaworthy EX21 5RU
www.devilsstoneinn.com
donated by the Inn Sign Society

In adding angels it seems only fair to acknowledge the opposition too. Satan (The Devil) gets fewer pubs named in his honour or as warnings, but this is a good one.

The Devil, (himself a fallen angel), is seen sitting on a large boulder looking quite fed up with himself. The boulder is real and situated right by a local church (St Michael's). Legend declares that Lucifer put the rock there personally and once a year, on Bonfire Night, the stone is lifted while the church bells ring, just to make sure Satan isn't hiding under the rock ready to pounce out at the unwary. I wonder if he ever thinks to go there on any other day of the year instead.

17. Adam And Eve

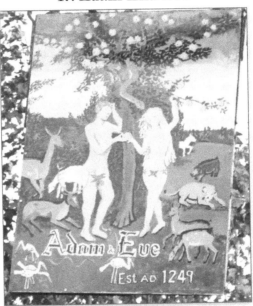

Lindum Road, Lincoln, Lincolnshire LN2 1NT
www.facebook.com/adamandevelincoln/ and
twitter.com/AdamandEveLincs
photo: Elliott Brown, (Creative Commons)

A few signs are daring enough to display nudity and get away with it because it is in the Bible, and here is a sign depicting the ultimate and earliest of what Brian

Aldiss called 'Shaggy God Stories'. In his *Trillion Year Spree* history of SF he described how many SF publishers in the 50's and 60's received manuscripts in which the last survivors of the bomb going off or, who set off to colonize a new world turn out to be Adam & Eve. Such book proposals usually went straight in the bin.

The couple are depicted in almost ghostly white among realistic forest creatures and fauna. Their strategic fig leafs alone give them modesty while the serpent snake looks down from the tree of forbidden knowledge.

The sign recognizes the pub's claim to date from 1249, though the sign is undoubtedly much more recent. The pub is now known as 'The Adam And Eve Tavern'.

There are independent Adam & Eve pubs and signs in many UK areas, including Chichester, Bristol, Cheltenham, Doncaster, Norwich, Swansea and Westminster, to name but a few.

General Mythology and Legend

Leaving scriptures aside, I'll now explore the broader range of myths that pub sign artists and speculative writers alike draw their inspiration from. I have already used the god Vulcan, and here are some creatures and characters he is sure to recognize.

18. The Griffin

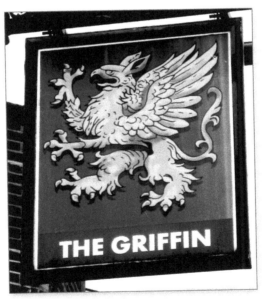

57 Brook Road South Brentford TW8 0NP
www.griffinbrentford.co.uk
donated by the Inn Sign Society

A mix of the lion, proud, strong, cunning and fierce king of the jungle and eagle, king of the skies, so very popular on heraldic coats of arms and shields.

As with many pubs listed here this bar shares its name with several other pubs, leaving me to have to choose the best of many available images. In most cases my choice is purely aesthetic but the excuse to include a sign from Brentford was a no brainer due to the town's frequent use in many of the novels of SF comedy author Robert Rankin.

Early Rankin novels featured the heavy drinkers of a fictional pub called The Flying Swan, leading many fans to visit Brentford looking for the real pub that might have inspired its creation. Several landlords in the area cheerfully claim their own taverns are the very place. In reality, The Flying Swan is probably a composite of many pubs and a product of the author's wild, extraordinary imagination. In his novel *Nostradamus Ate My Hamster*, Rankin has a fan embark on just such a pub crawl round Brentford looking for The Flying Swan. Brentford may therefore be the only town where every pub qualifies for inclusion in this study. It's only getting one though.

The Griffin was for many years the logo of the Midland Bank in the UK, and the bank had its headquarters in Brentford. Robert Rankin initiated a hoax in which he planned to have a few mates support his bogus claims to have actually seen the creature flying over the town. The mischievous joke took on a life of its own, and many people still believe the story. Books[1] were even written testifying to the creature's appearances. Rankin eventually owned up to the jape in the pages of *Fortean Times*.

[1] Including one by TV hypnotist Paul McKenna

19. The Unicorn Hotel

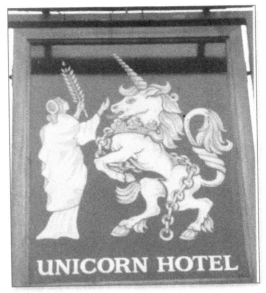

10 Broughton Road, Salford, M6 6LS
donated by the Inn Sign Society

The Unicorn in heraldry comes from the Scots, and the union with the English Lion. The Unicorn represented a creature that was wild and willing to die before it ever let itself be tamed. Its use on coats of arms and shields is likely to be affected by post-Brexit independence Referendums.

Unicorn depiction in fantasy literature and movies is of course very widespread. One legend had them wiped out by arriving too late to board Noah's Ark, but maybe the horn was a good snorkel.

This lovely white horse wrapped in chains is being approached by a virgin, who, according to folklore, can supposedly tame the fierce beasts.

20. The Phoenix

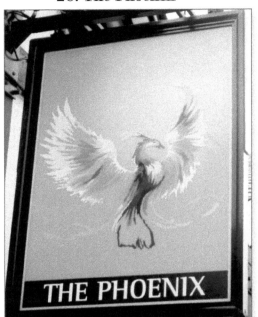

London Rd, Hazel Grove, Stockport, Cheshire, SK7 4AH
www.greeneking-pubs.co.uk/pubs/greater-manchester/
george-dragon/

Pubs with this name are often inns and taverns that closed down and are now re-opened under a new name and management, in keeping with the mythical bird born from its own ashes.

In London in the 18th century insurance investigators were known as Phoenix-Men because their role was often to check a property hadn't been torched just for the money. The old joke runs;

Man A – Sorry to hear about the fire burning down your pub

Man B – Shut up! That's next week!

The Phoenix appears in many fantasy stories, and

lots of readers will undoubtedly already be thinking of J K Rowling's *Harry Potter And The Order Of The Phoenix.*

21. The Mermaid

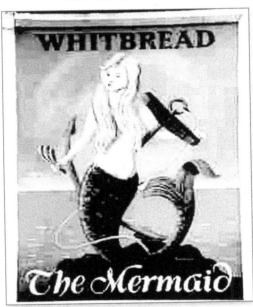

15, The Boardwalk, Portsmouth, Hampshire, PO6 4TP

An excuse for predominantly male artists to draw the exotic, even suggestive semi-naked female form on pub signs.

A common association with coastal, maritime and naval towns, a tattoo favourite for sailors and fishermen. Mermen are much more rarely seen on pub signs unless they are background figures in mermaid studies. The sea god Neptune / Poseidon does crop up sometimes though.

Here the mermaid, with her long hair providing

some modesty, has taken a ship's anchor which she has no difficulty holding despite its weight. Has she found it under the water, on its own or tethered to a wreck? Or has she stolen it from a surface vessel to cause it to crash into the rocks?

This pub has now closed.

Mermaids are popular thanks to the Disneyfied happy ending given to Hans Christian Anderson's tragic tale, though they have appeared in the writings of H G Wells (*The Sea Wife*), the movie *Splash*, and every SF TV series from *Voyage To The Bottom Of The Sea* to *Charmed*.

For other Mermaid pub signs look around Norfolk, Newquay, St. Albans, St. Mary's Island, Belfast, Ipswich and Colchester among many more.

22. George And The Dragon

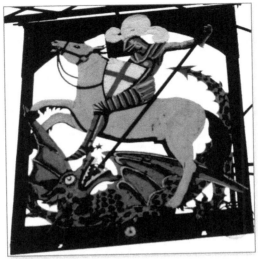

1 High St, Cheadle SK8 1AX
www.facebook.com/GeorgeAndDragonHG/

Dragons turn up in lots of British signs, especially the Green dragons of Wales, and they are frequently seen being ill-treated by St George, patron saint of cruelty to endangered species.

This sign is presented on wonderfully carved and coloured tin, so it is a particular favourite of mine. This sign captures the instant of the vicious kill, as the lance goes clean through the dragon's mouth and throat. Its scorpion tail is raised giving a sense of a really hard fought battle here.

A list of fantasy works involving dragons would run to a book in its own right. The regional legend of a wizard trying to buy one last horse for the sleeping cavalry resting under the hillside before they awaken to ride to one more glorious battle. A reclining horse can be seen in the painting's background.

Arthurian Legends

23. The King Arthur

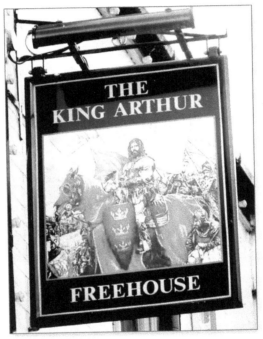

33 Benedict Street Glastonbury BA6 9NB
www.thekingarthur.co.uk

The stories of King Arthur are commonly represented on inn signs too.

This beautifully colourful presentation shows the King in full gleaming armour, riding his red-cloaked

war horse in a display of chivalric pageantry and power. Rich in symbolism and heraldry.

This is very aptly located in the town that claims connections to both Camelot and Avalon.

There are other King Arthur pubs in Walsall, Dudley, Tintagel, and Swansea.

24. The Wizard At Edge

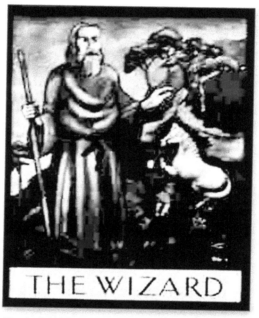

THE WIZARD

Macclesfield Rd, Nether Alderley, Alderley Edge SK10 4UB
twitter.com/TheWizardInn
Image donated by The Inn Sign Society

That's The Wizard At Alderley Edge to fill in the sign's missing word, and as this sign shows, it is often abbreviated further, to simply The Wizard. Many readers will already be expecting me to mention Alan Garner's *Weirdstone Of Brisingamen* here, so who am I to disappoint them?

The wizard of this novel and *The Moon Of Gomrath* sequel is Merlin in all but name and the Cheshire region of Alderley is steeped in the Arthurian mythos.

Garner writes in the forward to *Weirdstone* of a wizard trying to buy one last horse for the sleeping cavalry resting under the hillside before they awaken to ride to one more glorious battle. A reclining horse can be seen in the painting's background.

25. The Round Table

27 St. Martins Court, Leicester Square, WC2 WC2N 4AL
www.greeneking-pubs.co.uk/pubs/greater-london/
round-table/
Image donated by The Inn Sign Society

Another sign drawing on the legends, representing the Round Table's sense of equality among the knights taking a seat around it. This is marred by Arthur clearly sitting at the taller throne chair, and in effect encouraging his best knights to try to sit closer to him to show off his favouritism.

Watch The Signs!

Magic and Supernaturalism

26. Green Man

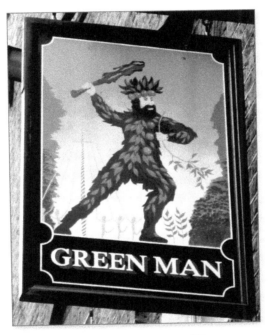

57 Berwick Street Soho W1F 8SR
www.thegreenmansoho.co.uk
Image donated by The Inn Sign Society

A sign and name with deep mysterious pagan origins. The Green Man is associated with the giant guardian of nature, steeped in fairie magic and forest lore, He therefore has strong ecological and environmental

educational value.

Kingsley Amis's comedy horror novel *The Green Man*, about a haunted pub, is set in such a bar, and of course Sergeant Howie stays at The Green Man Inn during his fatal visit to Summerisle in the original movie version of *The Wicker Man*.

Here the Green Man strides proudly round with Mayday Maypole fertility dancing going on behind him as he waves his club in the air. He closely resembles the Green Giant used to advertise sweet corn.

Arthurian legend's The Green Knight Is a variation on the theme, as are Herne The Hunter in the TV series *Robin Of Sherwood* and The Raven King in *Jonathon Strange And Mr Norrell*.

Witches and Witchcraft

27. Pendle Witch

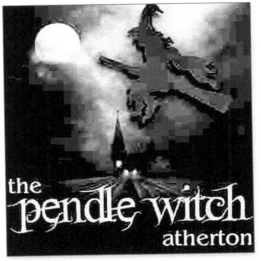

92 Warburton Place, Atherton, Greater Manchester M46 0EQ
www.facebook.com/Pendle-Witch-257916524247458/
Image donated by The Inn Sign Society

It is not surprising to see a witchcraft related sign close to the site of the all too real and tragic Pendle Witch Trials of 1612 where the twelve victims were just innocent local people, not practitioners of dark arts or early Quidditch competitors.

Here is a typical hallowe'enesque silhouetted figure in black hat riding her flying broomstick. A well-lit church is in the background shrouded in the mists.

There is also a currently unsigned Pendle Witch pub in Lancaster, close to where the Pendle Witches were tried and executed.

28. The Wicked Witch

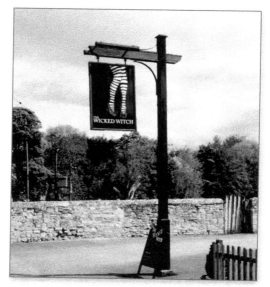

Bridge Street, Ryhall, Stamford, PE2 4HH
www.thewickedwitchexperience.co.uk/

An ambiguous sign depicting a woman's legs in stripy leggings and ruby-red shoes reminiscent of those Dorothy steals from the deceased Wicked Witch Of The East in *The Wizard Of Oz*, before killing the Wicked Witch Of The West too, for daring to stake her perfectly legitimate claim to them by direct inheritance.

That the sign avoids showing a face or torso, and the frame itself hangs from a detached gallows gives it an eerie echo of the fate of those who were genuinely hanged for witchcraft.

29. The Black Smock Inn

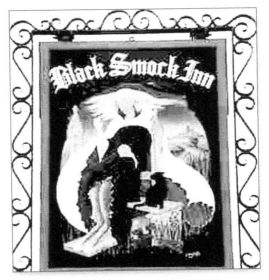

Stathe, Bridgewater, Somerset, TA7 0JN
Donated by The Inn Sign Society

This witchcraft related inn is also worth mentioning. The now removed sign depicted a lovely legend of a local witch famous for wearing a white smock. Pursued by an angry mob, she ran into the pub, then known as The George, and hid in the chimney, cunningly turning her smock black with the available soot and coal dust. She was eventually recognised despite her disguise and chased further until she transformed herself into a hare and escaped completely.

The story portrays a witch willing to put her own human ingenuity first (covering her clothes in soot) and only resorting to her magic as a last resort. This pub sadly closed down in 2003.

Watch The Signs!

Ghosts

Spooks appear on a few pub signs, but usually as a joke rather than from association with ghosts allegedly haunting the pub. Many pubs do of course claim to be haunted as perhaps the dead wish to go to places where they were happy during life. They hope to reunite with friends and enjoy more beer. They decline to leave at last orders.

Inebriation can of course lead to violence and some drinkers have been killed in fights or duels at or near pubs when a night out has gone terribly wrong.

Pubs have been used as makeshift mortuaries too after fatal accidents or killings in their vicinities. The cold cellars being good for keeping the body from decomposing sometimes meant that corpses were brought into the bars until an autopsy could be organized.

There is an increase in pub-related ghost-watch events and pubs are often used for morally questionable psychic night entertainments too. Pub signs relating to ghosts are nevertheless usually more frivolous. As with this classic example:

30. The Honest Lawyer

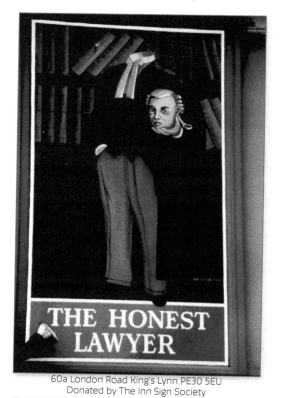

60a London Road King's Lynn PE30 5EU
Donated by The Inn Sign Society

This cruel taunt suggests the only honest lawyer is a dead one, or perhaps a rare man prepared to fight and even die for his principles. Here we have the traditional almost clichéd victim of decapitation doomed to carry his head under his arm forever more. This pub has now closed down.

31. The Quiet Woman

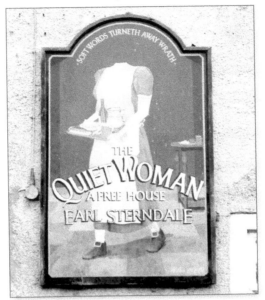

Earl Sterndale Buxton Derbyshire SK17 0BU
www.facebook.com/pages/the-QUIET-WOMAN-Pub-
Batumi/193545217377923
Photo: www.geograph.org.uk/photo/599504 Eirian Evans

Probably the most politically incorrect and blatantly sexist sign in the UK, suggesting a woman has to be dead to be quiet. Despite being silenced she is still seen dutifully acting as a servant and faithfully bringing food to the table on a tray. The sign suggests that her husband is a total monster.

Such signs are a useful educational reference for women to show just how appallingly chauvinistic many men can still be.

Note the sinister wording above the ghost. "Soft words turneth away wrath." A sinister call to wife-beating and even murder towards women deemed less than quiet or dutiful to their husbands.

Science and Scientists

To get to science fiction related pubs let's look at those depicting science itself. Without science there could be no science fiction. Many SF journals carry features on the latest scientific advances, which often inspire writers to create stories speculating on the utopias and dystopias that such stories might lead to.

Many scientists are avid SF fans. Einstein subscribed to John W Campbell's *Astounding* magazine, and many scientists have written SF themselves, including Fred Hoyle, Carl Sagan, and Gregory Benford,

Arthur C Clarke, Isaac Asimov, Robert Heinlein and Michael Crichton quit scientific careers to concentrate on their writing. How many future scientists are developing their love of physics, chemistry, medicine, biology astronomy and other sciences after watching movies, TV shows, and reading SF books today?

32. The Charles Darwin

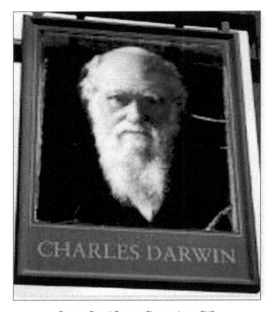

Sutton Road Sutton Shrewsbury SY2
Photo donated by Joel Smith of the Geek Out South West
SF group, Shrewsbury branch
https://geekoutsw.com/

It is very appropriate to find a pub named after Darwin in his town of birth. Creationists out there might see his theory of Natural Selection as science fiction in its own right.

Many mad scientist stories deal with attempts to speed up or divert evolution, (usually with inevitably dire consequences) including Mary Shelley's *Frankenstein* and H G Wells's *The Island Of Doctor Moreau.*

33. The Albert Inn

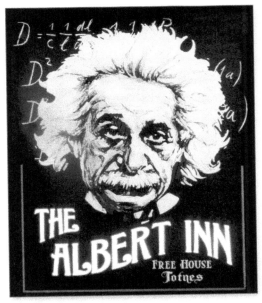

32 Bridgetown Totnes TQ9 5AD
www.facebook.com/TheAlbertInnTotnes/ and
twitter.com/Albert_Totnes
Image donated by Martin C Norman, of the Inn Sign
Society

Like most Albert pubs this would have been originally named in honour of Prince Albert, the famous lover of Queen Victoria, but at some point they decided to honour a different Albert instead and it is a great portrait of Einstein.

34. The Eagle

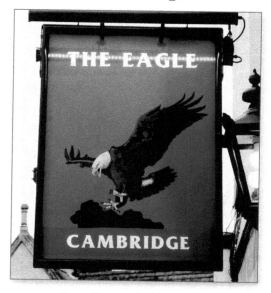

Benet Street Cambridge CB2 3QN
www.facebook.com/TheEaglePubCambridge/ and
twitter.com/TheEagleGK
Photo provided by SF fan Chris Cowan.

This pub not only celebrates a Nobel Prize winning scientific breakthrough. It played a major part in making it happen.

In 1953 Francis Crick, who was a regular patron there, held an impromptu press conference to announce that he and James Watson had cracked the discovery of DNA. There is a plaque on the pub wall and the bar serves an exclusive beer called Eagle DNA to commemorate the event.

The plaque reads:

> DNA double Helix 1953. "The secret of life."
>
> For decades The Eagle was the local pub for scientists from the nearby Cavendish Laboratory. It was here on February 28th 1953 that Francis Crick and James Watson first announced their discovery of how DNA carries genetic information.
>
> Unveiled by James Watson 25th April 2003.

The depicted eagle is swooping down with a fierce determined expression towards some unseen prey. The sign itself give no clue to the pub's scientific importance.

Space Exploration

Quite a few great signs depict our conquest of space including:

35. The Globe

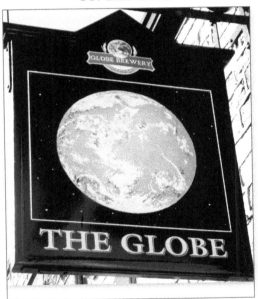

144 High Street West Glossop SK13 8HJ
www.facebook.com/TheGlobeGlossop/

Many Globe pub sign's depict the famous Shakespeare Globe Theatre. Glossop's presents a beautifully clear shot of the Earth viewed from space.

The pub in Glossop is also the World's first totally vegan pub. Even the beers are suitable for vegans.

36. The Early Bird

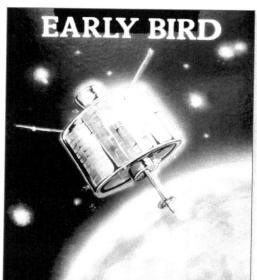

Beechdale Road, Bilborough, Nottingham, NG8 3FH
Donated by the photographer, Brian J Curtis

A double sided pub sign on a now closed estate pub (built specially as a local for a pot-war housing estate).

One side depicts a fairly conventional image of a bird catching a worm, in keeping with the proverbial cliché about how the early bird catches the worm.

The other side is of more interest for us as it depicts the Early Bird telecommunications satellite, officially called Intelsat, launched in 1965. It was the first commercial satellite to be given a geosynchronous orbit. It was deactivated in 1969, but briefly switched on again

in 1990, but it remains in orbit to this day.
The pub was demolished in 2007.

37. Man In Space

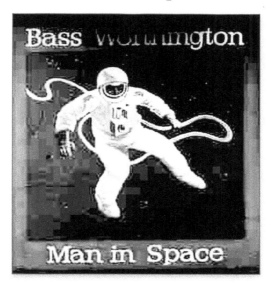

New Inn Lane, Trentham, Stoke-On-Trent, Staffordshire
ST4 8P
www.sizzlingpubs.co.uk/findapub/
yorkshireandthehumber/themaninspacestokeontrent
Image donated by The Inn Sign Society

The space-walk always strikes me as the bravest and loneliest duty for any astronaut. If the line severs, he or she is lost in the depths of space forever.

Here the intrepid adventurer drifts and floats freely, fully at one with the cosmos, but safely still attached to the vital lifeline.

38. Man On The Moon

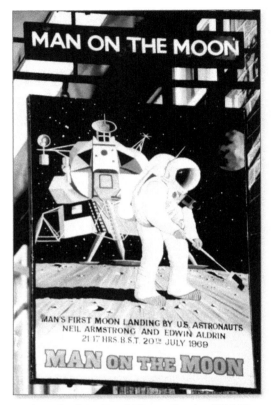

112 Headley Drive New Addington Croydon CR0 0QF
Image donated by The Inn Sign Society

From space-walking to walking on the Moon. The caption shows that this image captures the very first Moon Landing by Neil Armstrong and Buzz Aldrin in 1969 when so much speculative fiction suddenly came true.

Here Armstrong (or Aldrin) collect samples of moon rock and dust in close proximity to the Eagle Lunar landing craft. The caption notes the exact time of their historic touchdown.

39. Piltdown Man

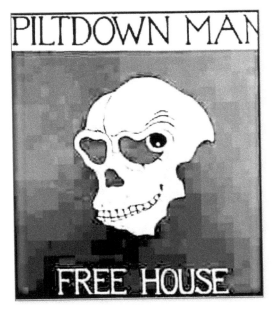

Goldbridge Road, Piltdown, Uckfield TN22 3XL
Image donated by The Inn Sign Society

This one depicts a famous scientific hoax. The Piltdown Skull found by a palaeontologist called Charles Dawson in 1912 was presented to the World as a newly found prehistoric ancestor to mankind. Though there was a great deal of doubt about the claim from the outset, it took until 1953 for the extent of the hoax to be exposed. The skull was part modern human and part orang-utan.

Many culprits have been touted as supposedly responsible including Sir Arthur Conan-Doyle (now exonerated) though Dawson himself seems the most likely perpetrator of the claim.

The sign depicts the skull of an ape with the rather lively fresh, alive looking eye of a human peeping out, set against a stark red background.

The pub has now changed its name to The Lamb.

40. Sir Richard Owen

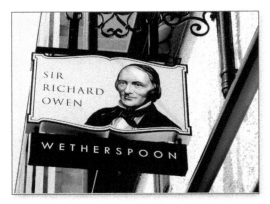

4, Spring Garden Street, Lancaster LA1 1RQ
www.jdwetherspoon.com/pubs/all-pubs/england/
lancashire/the-sir-richard-owen-lancaster

An antidote to the Piltdown Hoax is a pub and sign celebrating true palaeontology, as with this Wetherspoon's tavern honouring the very man who coined the word 'dinosaur'.

While the sign offers a worthy portrait of the great man, the pub provides little more information, other than a board giving a standard Wikipedia style summary of his life. A much more detailed and well-presented version is given elsewhere on the streets of Lancaster.

It would be great to see the pub interior decorated in dinosaur art and models, or movie memorabilia, (even Dino from The Flintstones) but their absence only reminds us of their extinction.

Science Fiction

So from science to Science Fiction itself.

41, 42 and 43. The Flying Saucer

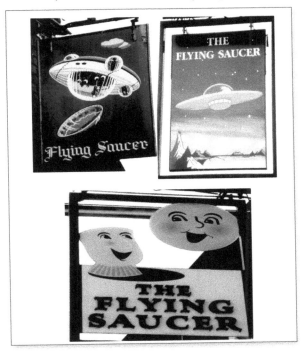

140 Hempstead Road Hempstead Gillingham ME7 3RH
www.facebook.com/The-Flying-Saucer-150755121787963/
All three images here donated by The Inn Sign Society, with image
43 specially taken for the book by ISS member P C Roulston.

UFO's adorn a few signs. This pub has had three

different flying saucer signs. In one a cup and saucer move through space engaging the Moon in cheery banter that has a fantasy and cartoonish root.

The follow up sign depicts a more traditional and brightly coloured space-hip, not unlike that of the *Forbidden Planet* movie. This appears to depict us approaching an alien World rather than its aliens popping by to see us.

A third sign depicts a more general UFO.

SF And Fantasy Authors

Quite a few pubs have links to specific writers in the genre. They include:

44. The Conan Doyle

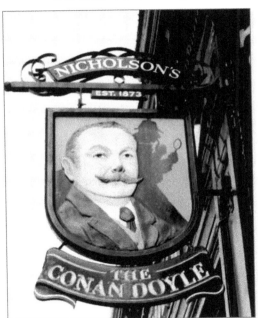

73 York Place Edinburgh EH1 3JD
www.nicholsonspubs.co.uk/restaurants/
scotlandandnorthernireland/theconandoyleedinburgh
Donated by SF fan Caroline Needham

Sherlock Holmes's creator also gave us *The Lost World* and other Professor Challenger stories.

The great Baker Street detective has a pub named after him in London's Northumberland Street conjoined to the Sherlock Holmes Museum. He had no science fiction or supernatural adventures of his own in the original canon of stories. The spectral seeming *Hound Of The Baskervilles* proved to be very much made of flesh and blood, while the *Sussex Vampire* was not sucking blood from sickly children but sucking out snake venom to save them.

Doyle was getting increasingly interested in occultism, but he could not express that through the ever sceptical ultra-rational Holmes, so Professor Challenger was created to enable Doyle to write about living dinosaurs, journeys to Atlantis (The *Maracot Deep*) and other fantastic escapades.

The author himself was born in Edinburgh which more than justifies the pub there celebrating his life and work. The sign portrays Conan-Doyle with the shadow of the great detective at work behind him.

A plaque on the inn wall reads:

> Arthur Conan Doyle creator of Sherlock Holmes was born at No.11 Picardy Place, formerly opposite here, on 22nd May 1859.

45. The Dickens Tavern

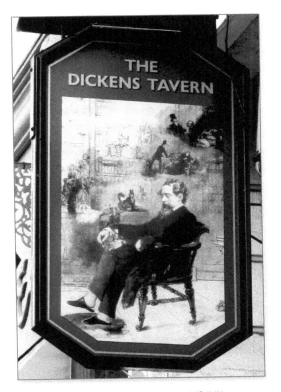

25 London Street, Paddington W2 1HH
www.greeneking-pubs.co.uk/pubs/greater-london/
dickens-tavern/
donated by The Inn Sign Society

Dickens gave us a few ghosts, and even time travel, especially in *A Christmas Carol* and *The Signalman.* There is also the bizarre supernatural Fortean death of Krook, by spontaneous Human Combustion in Bleak House. Dickens (played by Simon Callow) turned up in a Christopher Ecclestone led episode of *Doctor Who* (*The Unquiet Dead*).

Though Dickens lived much of his life in London,

no one should assume he frequented every pub there claiming that he was a patron. Many bars boast that Queen Elizabeth the First, Dick Turpin, Bonnie Prince Charlie and others stayed in their rooms or quaffed ale there, with no supporting evidence. Naming a bar after a hero does not have to be based on direct association.

46. The Edgar Wallace

40 Essex Street WC2 WC2R 3JF
www.facebook.com/pages/The-Edgar-
Wallace/105818802815917
Image donated by The Inn Sign Society

Though mostly associated with Noirish and seedy crime thrillers, Wallace also presented the first script treatment for the 1933 original and superior version of *King Kong*. The final movie print significantly changed the work presented in the end but the author is still given all due credit. He died a year before the movie was released.

He also wrote *Planetoid 127* in 1924, one of the first stories to imagine another Earth orbiting our Sun but on the exact opposite side of the Sun to our own orbit.

The sign shows Wallace at his desk looking out through the window over the whole of London, with the whole city as his inspiration.

47. The Orwell (At Wigan Pier)

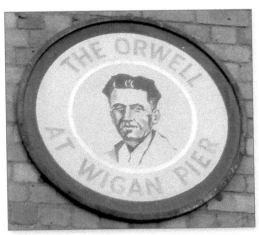

4 Wigan Pier Wallgate Wigan WN3 4EU
www.facebook.com/TheOrwell-Wigan-
Pier-410750630531/

The author George Orwell has two pub names associated with him, though neither reference *Animal Farm* or *1984*. His studies of destitution and homelessness in Wigan (*The Road To Wigan Pier*) naturally led to the town opening a pub in his honour on the pier itself.

The pub has now regrettably closed down.

48. The Moon Under Water

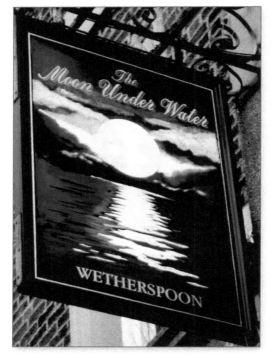

7 Market Place Wigan WN1 1PE
www.jdwetherspoon.com/pubs/all-pubs/england/
greater-manchester/the-moon-under-water-wigan

More importantly than with the previous pub connected to Eric (George Orwell) Blair, it was the 1946 essay called *The Moon Under Water* on what he considered the best ingredients of the perfect pub that inspired the foundation of the Wetherspoons business. The first Wetherspoons in London was called The Moon Under Water as was this one in Wigan. The name relates to the Moonraker legend of drunks trying to save the Moon from drowning, unaware that it is just its reflection in the water. As Orwell says in the essay, the perfect pub he describes does not actually exist.

The search for it is likely to be a fruitful as searching underwater for the reflected Moon.

Given that Orwell wanted men only rooms, good cigar and cigarette provision and beer serving in China cups his vision is unlikely to ever fully come to pass.

49. The Angel Hotel

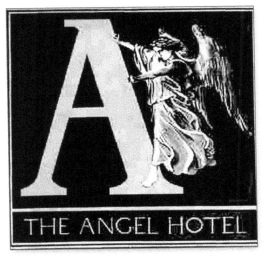

North Street, Midhurst, West Sussex, GU29 9DN
Image donated by The Inn Sign Society

One of several pubs linked to H G Wells. There is a pub named after him in Worcester Park, Kettering, with a poor quality portrait of the author.

Pub sign portraits of the famous ought to reflect what they did in life to deserve such an appraisal. Wells did much more than straightening his tie. A capture of him with pen and paper might be better or perhaps his time machine and a Martian tripod could appear in the background.

He lived in Midhurst for a time and set several stories

and scenes in pubs. He would go in the bars personally and simply write down what they looked like to create an authentic picture. Much of his descriptive writing was done live on location in his way. *The Invisible Man* rampaged through The Coach & Horses in the made up village of Iping, but critics and readers quickly matched its description to the Swan Inn in Midhurst, similarly, The Angel Hotel appears in his novel *The Wheels Of Chance*. Its current sign shows an angel moving or holding up a large letter 'A', Like a Wells story; it shows great imagination, wry humour and craftsmanship.

Pubs Known to be Frequented by SF Writers

50. Eagle And Child

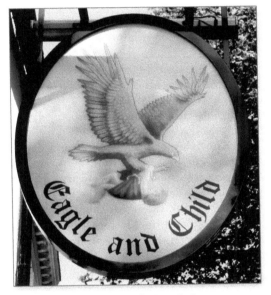

49 St Giles Oxford OX1 3LU
www.nicholsonspubs.co.uk/restaurants/southeast/
theeagleandchildoxford and
twitter.com/EagleOxford
donated by The Inn Sign Society

The Oxford Inklings met here frequently making it probably the best known SF related pubs, often mentioned in pub guides and recently covered in a

BBC TV show by TV chefs, The Hairy Bikers. J R R Tolkien, C S Lewis and Charles Williams drank here, as the pub's CAMRA sponsored wall plaque proudly testifies.

The Eagle And Child Oxford.

The Inklings.

Until 1963, the great writers of The Inklings, C S Lewis, J R R Tolkien, Charles Williams and others, met regularly on this spot. The conversations that have taken place here have profoundly influenced the development of twentieth century English Literature.

The pub name is itself semi-fantasy relating to the origin of the land owning Earls Of Derby. Their ancestor, the Earl of Lathom, covered up a lover's illegitimate pregnancy by supposedly adopting a child he and his mistress found in an eagle's nest on their Knowsley estate. They declared that the poor infant had to have been snatched up by an eagle from its pram and that they had no way to trace its true parents. Few believed the legend, but the image of the child in the talons of the eagle remains on the family crest and on the signs of pubs named after the family (often having been owned by them at one time or another).

The pub name may help explain how the eagles came to spring to the rescue at the close of Tolkien's *Lord Of The Rings*.

51. The Witch And Wardrobe

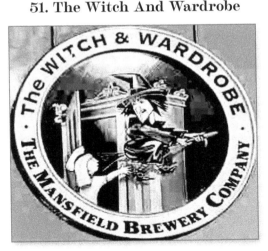

21 Waterside N, Lincoln LN2 5DQ
www.facebook.com/WitchAndWardrobeLincoln/
Image donated by The Inn Sign Society

Another pub associated with Inkling C S Lewis is The Witch And Wardrobe in Lincoln, which rather rudely leaves poor Aslan the Lion out, unless he is still locked in the Wardrobe. Most probably the full name just seemed too long to the sign-writer.

Here the Witch flies out of the wardrobe on her broomstick, and chats to the startled child as if asking directions, or warning the girl that there is a lion in the wardrobe.

52. The Bear

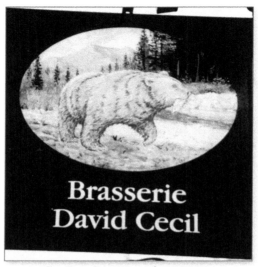

Charnham Street Hungerford RG17 0EL
www.thebearhotelhungerford.co.uk and
www.facebook.com/TheBearHotel/ and
twitter.com/bearhungerford
donated by The Inn Sign Society

This was a favourite drinking hole for once immensely popular horror and historic fiction author Dennis Wheatley who even has characters pop in there during his well-known novel, *The Devil Rides Out*. Other illustrious patrons have included Samuel Pepys and William Of Orange.

Wheatley also produced a 'library of the occult' series of books which not only included standard classic horror tales like Bram Stoker's *Dracula* but also genuine works on occultism such as the writings of Alasdair Crowley and Madam Blavatsky.

The word free sign, (The Brassiere David Cecil is a late addition) shows a brown bear in the woodland wilderness, with a fish in its mouth. The Bear pub would originally have been named after a nearby bear baiting pit or a place where bears were cruelly forced to dance for public entertainment.

53. The Shakespeare

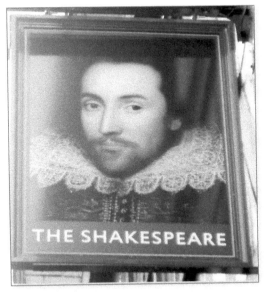

16 Fountain Street Manchester M2 2AA
www.facebook.com/The-
Shakespeare-151006674933918/

I can't really leave out the most depicted British author on pub signs, the Bard himself. He gave us ghosts, witches, Caliban, fairies and more besides. Numerous pubs take on his name, and not just in Stratford-On-Avon.

This is a genuine Elizabethan pub that was originally in Chester. Manchester had it moved to its new city centre location.

It is reputed to be haunted by an 18th century barmaid who sadly burnt to death getting her dress too close to the kitchen's candles in the early years.

No one actually know what Shakespeare looked like but this is a generally accepted widely used interpretation of his appearance.

Literary Characters

Fictional characters appear on quite a few signs.

54. Gullivers

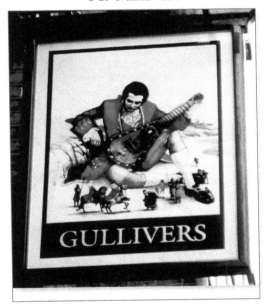

109 Oldham Street Manchester M4 1LW
www.facebook.com/GulliversNQ/ and
twitter.com/GulliversNQ

Jonathon Swift's famous traveller, seen here in his best known adventure among the Lilliputians.

The sign closely resembles a book illustration pencil drawing. The pub is actually quite large and spacious. The customers are all more than two inches tall.

55, 56 And 57. Jekyll And Hyde

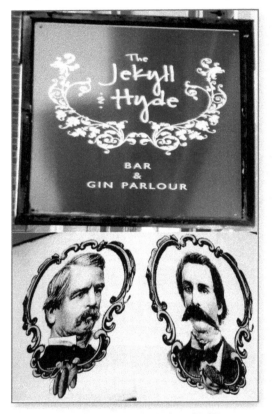

28 Steelhouse Lane Birmingham B4 6BJ
www.thejekyllandhyde.co.uk/ and
www.facebook.com/TheJekyllnHyde/ and
twitter.com/Jekyll_n_Hyde

A rather boring bland words only sign for a pub only named after Stevenson's conflicted hero-villain since

2003. Before then it was The Queens.

Below the main sign is a smaller tile depicting the two faces of the same man, one on each side. The pub interior is aptly set out on two floors bearing different characteristics with one floor reserved for quiet drinking while the upper floor is a performance space.

58. Puss In Boots

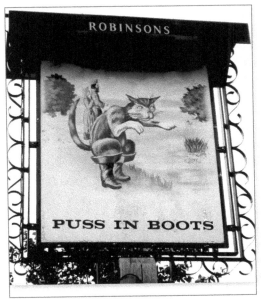

147 Nangreave Road Stockport SK2 6DG
www.almond-pubs.co.uk/puss-in-boots/ and
www.facebook.com/PussInBootsOfferton/ and
twitter.com/PussInBootsPub

Here the famous nursery rhyme, pantomime and Shrek companion character doesn't want to get wet saving someone from drowning, after all he's a cat and it would ruin his boots.

In some versions of the story the cat and human companion conspire to fake the drowning incident to

either steal clothes or conversely claim the man's clothes were stolen so the rich aristocrats and royals would offer them compensation or hospitality.

59. The Walrus And The Carpenter

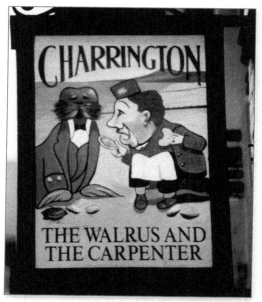

45 Monument Street EC3 EC3R 8BU
www.nicholsonspubs.co.uk/restaurants/london/
thewalrusandthecarpentermonumentlondon and
www.facebook.com/walrusandcarpenter45/ and
witter.com/The_Walrus45
donated by The Inn Sign Society

There are quite a few pubs with Alice In Wonderland connections, lots of Cheshire Cats especially but this is a more obscure and unique one. Here the somewhat unlikely couple sit down to enjoy their oyster picnic.

60. Uncle Tom's Cabin

51 High Street Wincanton BA9 9JU
Donated by The Inn Sign Society

This pub is unique. Many towns are twin-towned to others. Wincanton in Somerset is however the first to be twinned to an entirely fictional city, Ankh Morpork, the centre of much of the action in Terry Pratchett's Discworld novels.

The actual pub name relates to Harriet Beecher-Stowe's classic anti-slavery novel of 1852, an important work in the run up to the American Civil War. I don't doubt that Pratchett would happily share Beecher-Stowe's sense of humanitarianism.

Streets in Wincanton have Discworld names and the pub, though retaining its original name of Uncle Tom's Cabin, bears a new sign linking it firmly to the late great Discworld author, (who died shortly before the unveiling). Unable to get a copyright free copy of that I have used an earlier sign depicting a Mississippi riverboat scene related to Beecher-Stowe's novel.

In the Discworld novel Mort, the hero of that name goes in the Broken Drum pub and asks for a pint of Scumble, a potent cider brewed by witch and ale wife, Nanny Ogg. I wonder if such a brew is on offer at Uncle Tom's Cabin.

The pub has had numerous signs, and several different ones were shared with me for this project.

61. The Hobbit

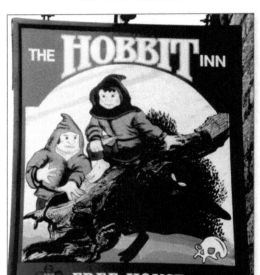

Church Street, Monyash, Bakewell, Derbyshire DE45 1JH.
donated by The Inn Sign Society

Now renamed The Bull's Head this pub dates back nearly 370 years and it is very popular with walkers and bikers visiting the Peaks.

Its old Hobbit sign depicts a scene from *The Lord Of The Rings* with Frodo, (brandishing Sting) and Sam about to run into Gollum. It is a well captured tense illustration of events in the book, but the sign really ought to depict Bilbo as the solitary Hobbit of the eponymous story.

Though other bars taking on the name Hobbit faced no problems, that at Bevois Valley Road in Southampton ran into serious legal protests from the Tolkien estate's

legal representatives. The pub there changed its name to The Hobbit as early as 1989 but it was 2012 when lawyers threatened to sue them for copyright infringement on the name. Even (then yet to be cast in Peter Jackson's film adaptation movie) actors, Ian McKellan and Stephen Fry defended the pub's entitlement and for now the civil case appears to have been dropped.

See also The Hobbit, Hob Lane Sowerby Bridge HX6 3Q, The Hobbit, 134 Bevois Valley Road Southampton SO14 OJZ.

Watch The Signs!

Science Fiction Movie Signs

62. Korova

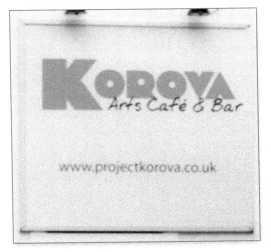

Charnley St, Preston PR1 2URS

There have been three bars taking *A Clockwork Orange's* Milk Bar name as their own. There is a pub in Aberdeen and a now closed night-club / music venue in Liverpool but this is the sign for the Korova in Preston, (now also unfortunately shut).

Anthony Burgess's novel depicts the bar serving milk because it can't sell alcohol to the under aged, but the milk is spiced with all manner of illegal drugs anyway, making the milk bar a favourite haunt for the murderous Droog gang. No doubt the real Korova bars have been much more law abiding.

Watch The Signs!

Doomsday Signs

63. The World's End

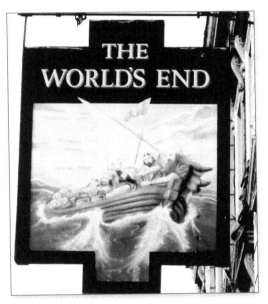

174 Camden High Street Camden NW1 0NE
www.theworldsend.co.uk/
donated by The Inn Sign Society

The Edgar Wright / Simon Pegg movie *World's End* features a pub crawl through the Apocalypse, using fictional pubs (complete with signs) but filmed in real locations in Welwyn and Letchworth Garden Cities. The actual twelve bar Golden Mile pub trail is now very popular there with beer drinkers and students.

The final pub appearing in the film is appropriately called World's End and there are actually several pubs that really do carry this name. They are often set on the edge of villages to indicate that there is nothing worth seeing or going to for miles beyond, though as towns kept growing, the message got meaningless very quickly.

Some World's End signs do go for a witty Armageddon related image to illustrate their name. This sign in Camden shows sailors literally reach the end of a flat World, this could easily illustrate an early Terry Pratchett Discworld novel.

64. The Worlds End

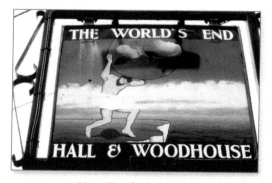

Almer, Blandford DT11 9EW
donated by The Inn Sign Society

Same pub name, different location no apostrophe, and quite a different 'end'.

Here Atlas decides he's just had enough of having the burden of carrying the whole World on his shoulders and throws it over a cliff. That ends the World and also this book. I hope you get a chance to see lots of pubs and quaff a few ales before your World ends.

Additional Pubs

OK, not quite the end; I lied. It seems wrong to end the book on such an absurd note of pessimism.

When I first mentioned to SF fans that I was preparing my 17th April 2017 talk on pub signs relating to science fiction, fantasy and horror a few expressed doubt that there could possibly be enough material to run it with. I already knew I could easily fill the hour with pubs to spare but I was eventually stunned by how much had to be left out.

Added to that, when I invited my wonderful audience to share details any pubs they knew about too, many more great suggestions surfaced, some of which are already incorporated in the main body of this book.

Here are just a few others I know of which almost gained fuller address

The Castle – Oldham Street, Manchester – a leading performance venue, the pub has played host to many poets, novelists and short story authors, including Rosie Garland, author of the sublime fantasy novel *The Palace Of Curiosities*. Rosie's alter-ego Rosie Lugosi, the Vampire Queen and lead singer of punk band The March Violets has also played there, as have I. Another writer linked to the pub is John Cooper-Clark, punk poet author of *I Married A Monster From Outer Space*.

Steampunk fans should note that there are many genuine Victorian pubs in Britain, as this was the period when more pubs opened than ever before or since. Many of the pubs owe their names to the height of the Industrial Revolution: railway pubs, Navigation Inns along the canals, pubs named after The Spinning Jenny and other major invention are all around us too. Then

there are the pubs named after notable Victorians from Isambard Kingdom Brunel to Robert Peel, The Duke Of Wellington, and Prime Ministers Disraeli & Gladstone. Queen Victoria, along with her consort, Albert, have many pubs named in their honour, including one in a popular mainstream BBC TV soap opera.

The nation's first steampunk theme bar, Cogs is in Birmingham, but sadly lacks a true pub sign at present. It is not the first steampunk pub in the World though, as that distinction goes to Enigma in Romania. I hope to look at international pubs and their signs in future studies.

The FAB Café Cult TV And Movie Theme Bar in Manchester is full of SF memorabilia from life sized Daleks to autographed movie posters. The managers also helped resurrect long running SF monthly magazine Starburst magazine and run regular podcasts and radio shows from their own office. Companion bars in Liverpool and Leeds have now sadly closed. Alas, again, the bar lacks true pub signage.

Jamaica Inn on Bodmin Moor may be one of Britain's most famous literature and movie related pubs, as Daphne Du Maurier wrote her famous and eponymous though down to Earth tale of Cornish smugglers while staying there. She went on to pen the horror genre classic *The Birds* (also filmed by Alfred Hitchcock) and her short story *Venice* was filmed as the terrifying *Don't Look Now*. The pub was later owned by thriller writer Alastair Maclean. Its sign has no idea what Cornish Smugglers looked like, so it depicts Long John Silver the pirate instead, complete with Captain Flint the parrot on his shoulder.

Fantasy related signs are in no way in short supply. Look out for these pub names yourself if you wish. Consider it an informal, non-mandatory homework assignment.

Bacchus, Camelot, Cupid, The Cheshire Cat, Druids, Flying Dutchman, Flying Horse (Pegasus) The Golden

Fleece, Gremlins, Hobgoblin, Lancelot, Leprechaun, March Hare, The Queen Of Hearts, Sea Witch, and Woden, to name but a few.

Happy searching. Do please share your finds with me.

—Thank you. Arthur.

About the Author

I am a 57 year old Preston based, Manchester, England born author of science fiction, poetry, erotica, horror, non-fiction, and much more. Educated to degree level in the Humanities, I am an ex-member of an extremist religious cult, who helps warn people of the dangers such organizations present.

More pleasantly I have been involved with historic re-enactment societies, and I am an award winning performance poet, dramatist and until my recent geographical relocation, a community radio presenter. My first radio podcast play, as author, director and actor, *Wendigo Water*, was broadcast in 2015. I write on a number of websites, and blogs and often get to talk on my life experiences in the media. I present talks on subjects ranging from pub sign histories, to cults, burlesque and the definition/nature of comedy. I am currently helping to organize Preston's 12th One In Four movie festival which encourages greater understanding of mental health issues.

I welcome feedback from readers and if you have images or stories relating to pubs you have seen or visited I would be very interested in seeing them. If you are happy for me to use your photos in future talks or publications I will happily mention you in my acknowledgements.

E-mail arthurpeterchappell@hotmail.co.uk

Facebook www.facebook.com/arthur.chappell

Twitter twitter.com/arthurchappell

Pinterest uk.pinterest.com/arthurchappell/

Acknowledgements

There really are too many people to thank. Various pub landlords offered information on their bars and occasional complimentary ales. Mary Crumpton in Manchester and Verity Griffith at the Ingol Intact Community Centre, Preston, gave me my first opportunities to talk publicly on pub signs. The committee, organizers, and attending fans at the Innominate Eastercon (2017) who came to the talk that led to this book being produced very soon afterwards.

Photo Credits –signs without accreditation footnotes are all taken by me. Many images were kindly donated by the Inn Sign Society, (especially their 2018 membership secretary Roger Pester and photo-archivist Derek McDonald), who have many pub sign photos on their database. The Wolf & Whistle sign was sent by the managers of the Tan Hill pub where the sign is located. Other images are in the public domain, through the Creative Commons website https://creativecommons.org/licenses/by-sa/2.0/ and therefore free of copyright restrictions. Photos drawn from Creative Commons were taken by Eirian Evans, and Bob Harvey.

Chris Cowan, from Cambridge captured the photo of The Eagle pub especially for me. Caroline Needham similarly donated The Arthur Conan Doyle sign in Edinburgh.

Joel Smith of the Geek-Out South West SF group, Shrewsbury branch https://geekoutsw.com/ provided the photo of the Charles Darwin pub sign in Shrewsbury. Images of this sign were also submitted by Robin Jasper of the Shrewsbury Over 45's Social Club. www.meetup.com/Shrewsbury-Over-45s-Social/ and Graham Cossins

of CAMRA Whatpub Shrewsbury.

Brian J Curtis donated the photo of The Early Bird sign, from Bilborough, Nottingham. Martin C Norman donated the Albert Inn, Totnes image and an image of Uncle Tom's Cabin in Wincanton, though I used a different image of the same pub in the end, (from the Inn Sign Society archives).

Thanks to Nuriya (Nuri) Abbasi and Lizzie Leeke for assistance in creating some cover art and publicity flyers. ,

Thanks to the editors at Shoreline Of Infinity for their faith in me too.

Finally, apart from everyone I undoubtedly forgot, thank you for buying and reading this. Now I'm off to the pub (for a beer).

Bibliography

Pub Related Books And Journals

At The Sign Of.... Various issues of the journal of the Inn Sign Society, published three times a year.

Delderfield, Eric R – British Inn Signs And Their Stories 1965 David & Charles

Dunkling, Leslie – A Dictionary Of Pub Names – 1987 – Wordsworth Press

Halliwell, Stephen R – Preston Pubs – 2014 – Amberley Press

Larwood, Jacob & Camden-Hotten, John – English Inn-Signs – 1951 – Blaketon Hall Press

Protz, Roger – The Good Beer Guide – CAMRA Various editions

Simpson, Jaqueline – Green Men And White Swans – 2010 – Random House

Waters, Colin – A Dictionary Of Pub, Inn And Tavern Signs – 2005 –Countryside Books

SF & General Literature Referred To.

Aesop – Fables – c.600 BCE – Various editions

Aldiss, Brian – Trillion Year Spree – 1986

Amis, Kingsley – The Green Man – 1969 – Penguin Books

Hans Christian Anderson – The Little Mermaid 1837 – Various editions.

Beecher-Stowe, Harriet – Uncle Tom's Cabin – 1852 – Wordsworth Classics

Bible, The – Especially Genesis & Revelation – various versions

Burgess, Anthony – A Clockwork Orange – 1962 – Penguin Books

Carrol, Lewis – Alice's Adventures In Wonderland 1865/1871 – various editions

Chappell, Arthur – Ben Brierley 1988 – Passages Bolton University (Institute Of Higher Education Student publication)

Clark, John Cooper – I Married A Monster From Outer Space – in Ten Years In An Open Neck Shirt 1983 Arena Press

Clarke, Susanna – Mr Norris And Jonathon Strange 2004 Bloomsbury Press

Clute, John & Grant, John – The Encyclopaedia Of Fantasy – 1997 – Orbit Press

Clute, John & Grant, John – The Encyclopaedia Of Science Fiction – 1993 – Orbit Press

Dickens, Charles – A Christmas Carol – 1843, Bleak House, The Signalman – 1866,

Doyle, Sir Arthur Conan – The Adventure Of The Sussex Vampire, The Hound Of The Baskervilles, The Lost World – 1912, The Maracot Deep – 1927. Various editions

Du Maurier, Daphne – The Birds – 1952, Jamaica Inn – 1936, Venice – 1952. Penguin Books

Garland, Rosie – The Palace Of Curiosities 2013 – Harper-Collins

Garner, Alan – The Moon Of Gomrath (1963), The

Weirdstone Of Brisingamen (1960), Fontana Press

Grahame, Kenneth – The Wind In The Willows – 1908 – various editions

Horwood, William – Duncton Wood – 1980

Kipling, Rudyard – The Jungle Books 1894-1895 – various editions

Lewis, C S – The Chronicles Of Narnia, – 1950-56, The Screwtape Letters – 1942,

Orwell, George – 1984 – 1949, Animal Farm – 1945, The Moon Under Water – 1946, The Road To Wigan Pier – 1937. Penguin editions

Pratchett, Terry – The Discworld Books 1983-

Puss In Boots – Various versions

Rankin, Robert – Nostradamus Ate My Hamster & various Brentford centred tales – 1981 onwards.

Rowling, J K – Harry Potter And The Order Of The Phoenix – 2009 – Bloomsbury Press.

Shakespeare, William – Various plays

Shelley, Mary – Frankenstein – 1818 – various editions

Stevenson, Robert Louis, – The Strange Case Of Dr Jekyll & Mr Hyde – 1886 – various editions

Stoker, Bram – Dracula – 1897 Various editions

Tolkien, J R R – The Hobbit -1937, The Lord Of The Rings (1954-5),

Wallace, Edgar – Planetoid 127 – 1924 (also the original script for King Kong – 1932)

Wells, H G – The Island Of Dr Moreau – 1896, The Invisible Man – 1897, The Man Who Could Work Miracles – 1898, The Sea Wife – 1901 The Time Machine – 1895, The War Of The Worlds 1898, Book Club Associates editions and others.

Wheatley, Dennis – The Devil Rides Out – 1935, and his Library Of The Occult (editor) Pan Books

Movies Referenced

Alice In Wonderland – 1951
An American Werewolf In London – 1981
Bambi – 1942
Dune – 1984
Fantasia -1940
Forbidden Planet -1956
King Kong (1933)
The Lion King – 1994
The Little Mermaid – 1989
Monty Python And The Holy Grail – 1975
Monty Python's Life Of Brian – 1979
Planet Of The Apes (various versions, sequels and spin-offs)
Splash – 1984
Twin Peaks: Fire Walk With Me – 1992
The Wicker Man -1973
The Wizard Of Oz 1939
World's End – 2013.

TV Shows Referenced

Charmed, (episode – A Witches Tail) – 2002
Dr Who (especially The 2005 episode The Unquiet Dead)
Robin Of Sherwood –1984-86
(Classic) Star Trek – 1967-69
Twin Peaks – 1990-91/ 2017
Voyage To The Bottom Of The Sea – (Episode – The Mermaid – 1967)

Websites

Beggar's Bush – site showing a medieval Ale stake image – www.beggarsbush.org.uk/ anon-londons-ordinarie-1674/

Creative Commons – https://creativecommons.org/ licenses/by-sa/2.0/ Copyright free photo-sharing site.

Fortean Times – A forum discussion on the Brentford Griffin Hoax http://forum. forteantimes.com/index.php?threads/ whatever-happened-to-the-brentford-griffin.46348/

Homestead – www.homesteadbb.free-online.co.uk/ author.html Lists many British pubs with a strong literary connection.

The Inn Sign Society – www.innsignsociety.com/ Website of the only organized body of pub and inn-sign aficionados in Britain. I am proud to be a member myself.

George Orwell – The Moon Under Water 1946 – www. orwellfoundation.com/the-orwell-prize/orwell/ essays-and-other-works/the-moon-under-water/ The full free text download of Orwell's highly influential mock-essay on the ingredient needed for a perfect pub.

Pubs Galore – www.pubsgalore.co.uk/ One of the best pub by pub guides to the UK – very comprehensive.

Wetherpoons – www.jdwetherspoon.com/pub-histories Wetherspoon's provide a good easy access history of the pubs they own and concise explanations for their given names.

What Pub – https://whatpub.com/ The Campaign For Real Ale (CAMRA) pub guide online.

Watch The Signs!

SF Pub Signs Pubs Use:
an A – Z

Here is an alphabetical list of all pubs used in the text. The numbers correspond to the photo number in the text. Addresses, postcodes and (where available) official websites are given in the main text. (as footnotes in the case of pubs mentioned but with no direct genre association).

With the current rate of UK pub closures please check the pubs you hope to visit are still open before travelling to them. The numbers to the left refer to the pub / photo, not the page numbers.

17. *Adam & Eve – Norwich*
32. *The Albert Inn – Totnes, Torquay*
51. *The Ancient Mariner – Hove*
15. *The Angel – Collyhurst, Manchester*
49. *The Bear – Hungerford*
3. *Beckets – Glastonbury*
28. *The Black Smock Inn – Stathe, Somerset*
4. *Canterbury Tales – Canterbury*
31. *The Charles Darwin – Shrewsbury*
41. *The Conan Doyle – Edinburgh*
16. *The Devil's Stone – Exeter*
42. *The Dickens Tavern – London*
14. *Drunken Duck – Walsall*
33. *The Eagle – Cambridge*
47. *The Eagle And Child – Oxford*
34. *The Early Bird – Nottingham*

43. *The Edgar Wallace – London*
39. 40. *The Flying Saucer – Gillingham*
12. *The Fox And Grapes – Preston*
8. *The Frigate – Whitfield, Manchester*
22. *George & The Dragon, Cheadle, Stockport*
35. *The Globe – Glossop, Derbyshire*
26. *The Green Man – Soho London*
18. *The Griffin – Brentford*
52. *Gullivers – Manchester City Centre*
46. *The H G Wells – Kettering*
60. *The Hobbit – Southampton*
29. *The Honest Lawyer – King's Lynn*
53. 54. 55. *Jekyll & Hyde + 2 Small prints – Birmingham*
23. *King Arthur – Dudley*
61. *Korova – Preston*
5. *Magna Carta – Lincoln*
36. *Man On The Moon – Croydon*
21. *The Mermaid – Portsmouth*
45. *The Moon Under Water – Wigan*
10. *The Old Fox And Hounds – Croydon*
46. *The Orwell At Wigan Pier – Wigan*
6. *The Ostrich – Prestwich, Manchester*
27. *Pendle Witch – Lancaster*
20. *The Phoenix – Hazel Grove, Stockport*
9. *The Piccadilly – Manchester City Centre*
37. *Piltdown Man – Piltdown*
56. *Puss In Boots – Offer ton, Stockport*
30. *The Quiet Woman – Buxton*
7. *The Railway Hotel, Moston Manchester*
2. *Roman Bath – York*
25. *The Round Table – London*
50. *The Shakespeare – Manchester City Centre*
37. *Sir Richard Owen – Lancaster*

57. The Swan Inn – Midhurst, Kent
13. Tan Hill Inn – (The Wolf And Whistle) – Richmond, Yorkshire
59. Uncle Tom's Cabin – Wincanton
19. The Unicorn – Manchester City Centre
1. The Vulcan Arms – Sizewell
11. The Waltzing Weasel Offerton, Stockport
58. The Walrus And The Carpenter – London
48. The Witch And Wardrobe – Lincoln
24. The Wizard At Edge – Alderley Edge
13. The Wolf And Whistle (See Tan Hill Inn) – Richmond, Yorkshire
63. The Worlds End – Blandford
62. World's End – Camden

Needing Digital? You can download a heavily discounted digital edition of this book including colour images of the signs. Head to

www.shorelineofinfinity.com/wtswts

You'll be asked one simple question – answer correctly and you'll be given a code for 50% off.

Watch The Signs! Watch The Signs! is available in PDF, Kindle and ePub formats.

The stories continue...

Shoreline of Infinity Science Fiction Magazine
www.shorelineofinfinity.com

Lightning Source UK Ltd.
Milton Keynes UK
UKHW022155050419
340570UK00005B/137/P